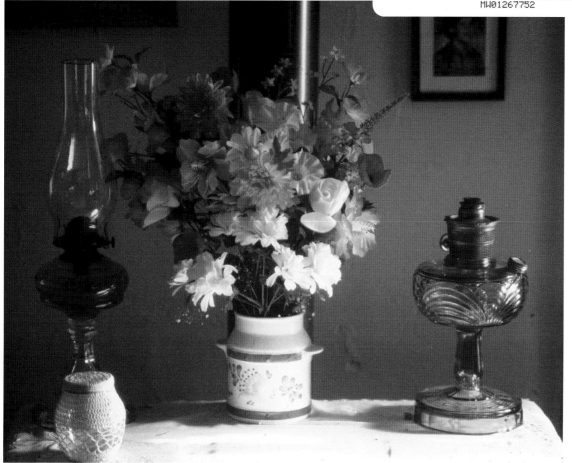

Stovepipes, Oil Lamps & Authorship

Symbols now, in the twenty-first century, of heat and light, old
Items extending both comfort and activity, encouraged the bold,
Inspired hope, created atmosphere for quilters, writers, dreamers.

As recently as 1985, oil lamps decorated Marie's Palmyra living room
in northeast Missouri, near Florida, MO, birthplace of Samuel Clemens.
We heard all about Mark Twain, while spending time 'round Hannibal.
After a childhood bout with measles, Mark Twain became a printer's
apprentice, wanted to become a world traveler and did. Temperament,
and circumstance, he said, brought him an invite to write his book,
The Innocents Abroad. Twain claimed to have become an author
because he'd suffered measles when he was twelve years old.
Would that measles or world travel made authorship that simple.

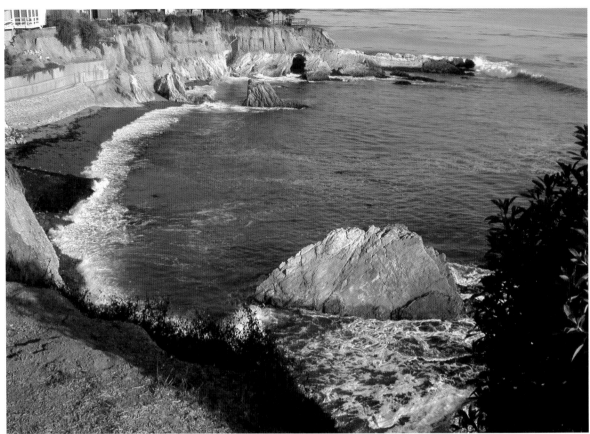

Pismo Beach, CA

Photographing the Pacific Ocean

Water in a dew drop, tear drop, floating ice cube
May flow or fill, flood or refresh, in part essential
As the life sustaining fluid spilling over rocks in spring,
Providing homes for fish and frogs in a provincial
Lake, or swelling an ocean wave that roars to fling
Its gravel along the shore, then foam up, then recede,
Smoothing a wet path for crabs and wistful people.

Metaphorically, the allusion to water,
Possibly the premier analogy used in every art,
Or the bottom line allegory in most literature,
Leaves us drowning, fishing for words, in part
Flooded with emotion, twisting toward an aperture
Small enough to assure the greatest depth of field
To record a near perfect image of that precious element, water.

On Becoming A Fish

Skirting the edge of a gravel beach,
Must be where life began to reach.
I was feeling a sudden urge to disrobe,
To become a life form at home in the shoals.

I'd swim freely among those of my kind,
Believing in nothing but what I'd find
While surveying depths for food or to mate,
With nothing more serious to contemplate
Than to avoid those bigger and hungrier than I.

Later with steak and salad and such
I ordered fine wine to warmly quench
A thirst derived from thinking too much.
As an intelligent woman, I did resist
The temporary appeal of becoming a fish.

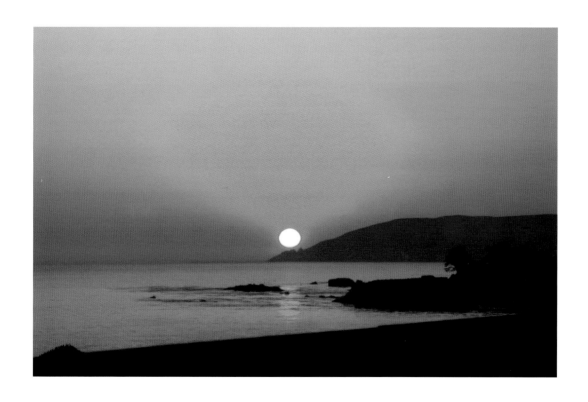

Water Beetle & History of Boats

Water beetle on a leaf, a perfect sail.
Duck with waxy feathers, feet for rudders.
Fish equipped with tiny oars, strong aft motor.
Turtle trusts his floating log for warmth.
Lily pads form a path across the bog,
Thick green roads for snakes and singing frogs.

Once after fire, shelter, weapons, words,
Compelled was man to create what he observed,
For easy transport over water he'd need boats.

One day years ago along the Tennessee,
The Yellow, Yangtze, Nile, the Mississippi,
Future sailors contrived a carved-out log, or, plank,
A craft of woven reeds to fulfill needs from beyond
The place they searched for food, or land, on which
To hunt. Inflated skins were known to float,
And may indeed have been man's first real boat.

Little evidence of this exists before thousands of years
Ago when humans simultaneously made note
Of floating trees, bobbing buckets, wooden bowls.
They learned that families could survive
Suspended on the liquid surfaces of lakes or streams.
They could sail distances to better lands and cultivate
Richer, ever-farther reaching riverbanks.

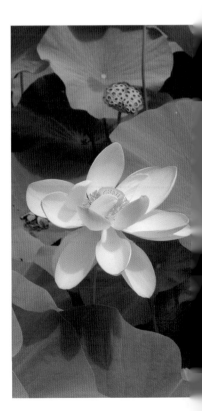

History of Boats, cont.

Floating homes became necessity as wealth and power
Moved inland and those in need of food remained afloat
To sail away from danger, unlike those behind
The wooden boards, or fine brick walls,
Or sandy concrete mixed with straw,
Or marble palaces with bamboo-covered walks.

Human independence includes The River, and
The People need their tight connections to the land.
Would that water was immune to waste from
Crowds, work, war and force of change.
Would that humans were immune to waste from
Plants, progress, peace and force of change.

Beetles crawl from leaf to reed for need of food.
Ducks lays eggs on grass above the beach.
Fish feed and breed in their own element.
Turtles leave a sun-warmed log to seek a mate.
Lilies float as small white bowls within the fog.
People row their wooden boats across the bog.

Acres of giant water lilies. A pond in Forest Park, Springfield, MA.
A tribute to Monet and many artists' attempts to duplicate
his mastery of similar subjects.

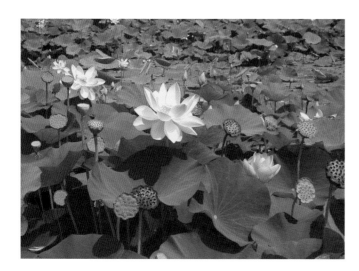
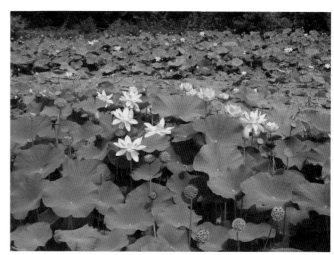

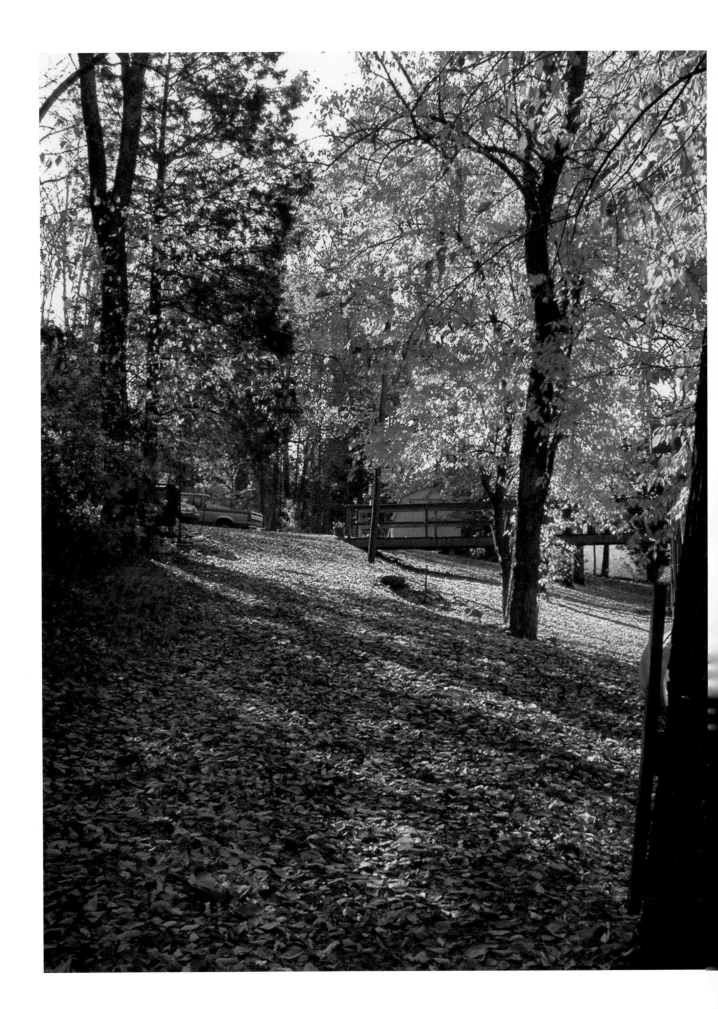

From Semi-Retirement

When you look for me, here's where
I'll be not so many years from now.
Where an oak tree squeaks against a hedge,
A honey locust hides a ledge
Of broken limestone. It's where I'll be.

Where the creek winds through an ancient
Channel of solid rock, and the downies knock
Near an antique sign from a hickory panel
Is where I'll be.

Where a resting owl, hawk, deer or duck
Ignore each other and Dwayne's old truck
Above the pond, through the muck --
That's where I'll be.

In the rain when water splashes and slaps
Over mossy, miniature carpets and mats
To flood the meadow and fill my spirit --
That's where I'll be.

Top of the hill near a fence on a log
Polished by those who sit pondering toads
Or beetles, bluebirds, tulips and fog,
You may find me.

This is my space. See that tree?
Come share the wonder. Its essence is me.

Scribed: February 27, 1987
Retired: August 1, 1990
Photographed: November 20, 2007
Upper drive, The B & H Farm, Bedford County, TN

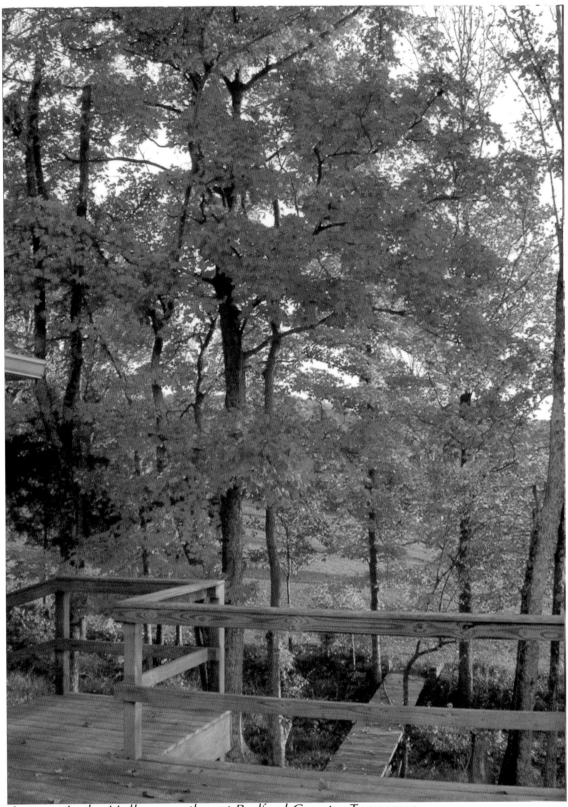

Autumn in the Hollow, southwest Bedford County, Tennessee

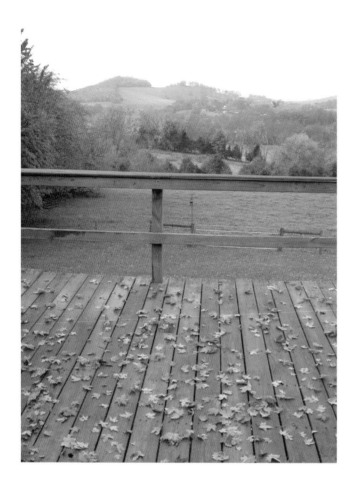

Indian Summer

Silence crawls across the deck.
Colors whisk across the patio,
Disappearing into a snifter
Of California Premium White.

Burgundy leaves from flowering pears
Arrange their hearts on empty chairs.

Leaves and spirits celebrate October
In passionate explosions of red and gold.

In conversations sweet and bold,
We dread the cold.

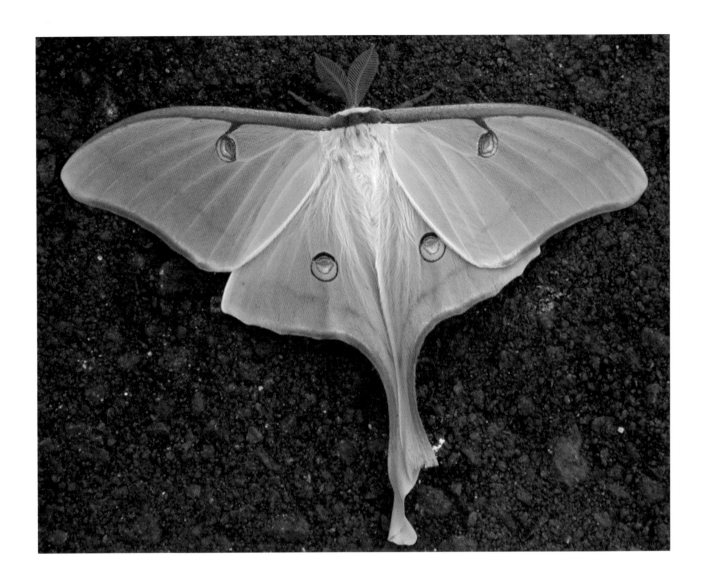

To Savor Beauty Beyond Dreams

We pull the blanket over our shoulders, bury our chins and
Seek the comfort of unconscious reverie in deep dreams.
We feel our muscles stretch and loosen, brain wandering as
Sound recedes into reviews of the day's events. Sleep comes.

Below the blanketing leaf on a dirt path, a snail moves its shell
Through warm light and moist sand seeking food and protection.
The same warm light dries the wings of a butterfly unfolding.
A Luna moth crawls from its cocoon, tail tip lost in the birthing.

To Savor Beauty Beyond Dreams, cont.

Later evidence of crash landings, smashing attacks, crushing dives
Reveal bits of that color and design Nature lavishes on creatures
We barely notice, as we return to our beds, pull up the blankets
And seek the artificial beauty we treasure and savor in our dreams.

Luna Moth: Parking lot near Lake Lure, NC
Luna wings on a stump: Bedford County, TN

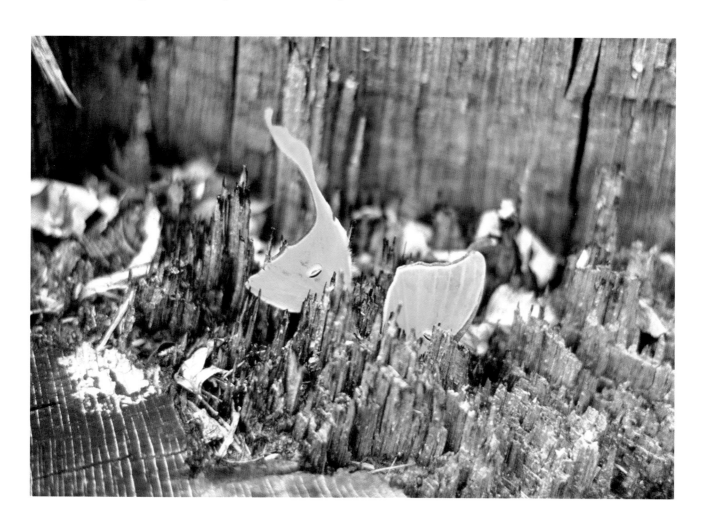

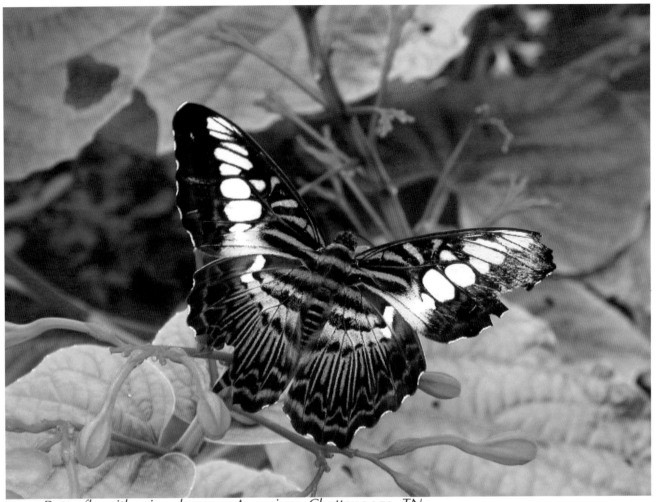

Butterfly with wing damage: Aquarium, Chattanooga, TN

Takes at least two hearts to fly ~

One to pedal the bicycle,

And one to believe it is possible

To get off the ground.

To Savor Beauty Beyond Dreams, cont.

A white and blue-black butterfly, days old in human time, nurses
Sweetness from favorite blossoms and displays a symmetrical beauty
Unmatched, but eagerly imitated by human designers of fabric, with
Patterns to thrill the imagination of those lucky enough to be observing.

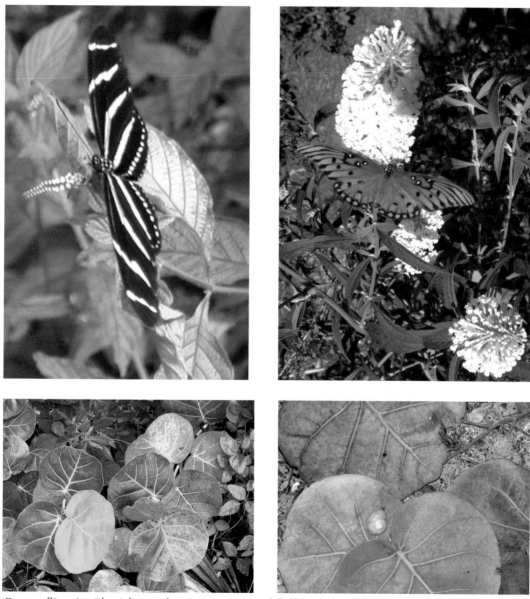

Butterflies in Florida and Tennessee and fallen leaves near a beach in Florida.
A snail on similar leaves near a walking path in Key Biscayne, FL

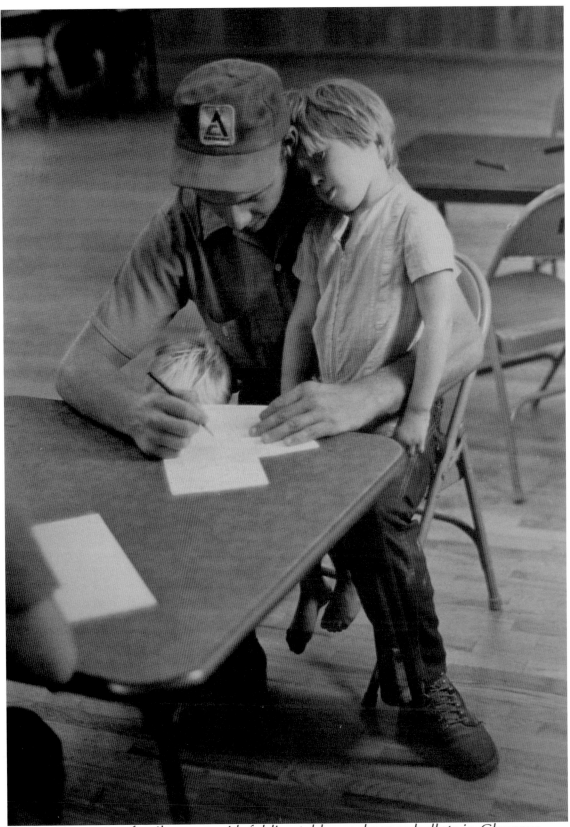

Voting Day was a family event with folding tables and paper ballots in Glasgow, Missouri, 1978, where for months every public activity was recorded on film.

American November Traditions

We gather to celebrate a tradition
Of our forefathers and mothers who elected
To share an attitude of gratitude for health, safety,
Potential peace between themselves
And native citizens of then, a not-yet
Conquered community in a new land.

We seek the same for friends and family,
Food, security, freedom and peace.
We are thankful for the good we have and the
Time we share. We plea to All Sacred Universal Entities
For strength, relief, truth,
Courage, confidence, compassion.
We acknowledge our differences.
We celebrate our common goals.
We seek patience, tolerance, and endurance.

Grateful for laughter, beauty, surprise,
Wonders we cannot explain,
We celebrate love.

We are thankful for homes, space, place,
People gathered with us, those alive, and
Those who grace us with their spirits.
We acknowledge our quaint place in the universe.
We are grateful to be free to choose how we gather, for
Whom we vote, to whom we pray, where we share opinion,
We are thankful for the Constitution of these United States.

Election day in Glasgow, Missouri, 1978. Family stories, public and private events were photographed during several visits by photojournalism students from the University of Missouri-Columbia. Those stories were published in a book, "Glasgow, Story of a Missouri Rivertown". Co-editors V.J. Hampton, Keith Graham and Stephan Savoia, 1979. Photos were used again in 1990, for lessons in layout. "Picture Editing and Layout" with Angus W. McDougall, VISCOM Press, UMC.

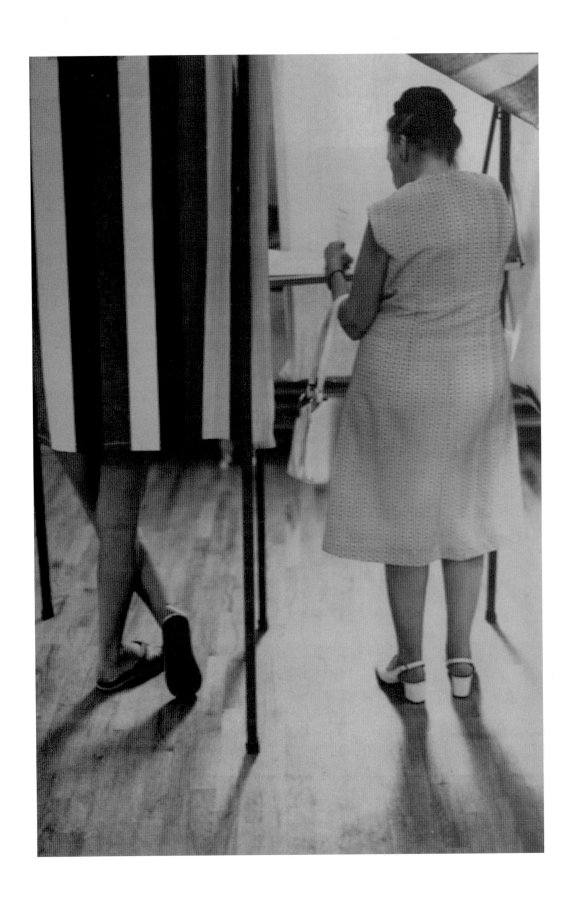

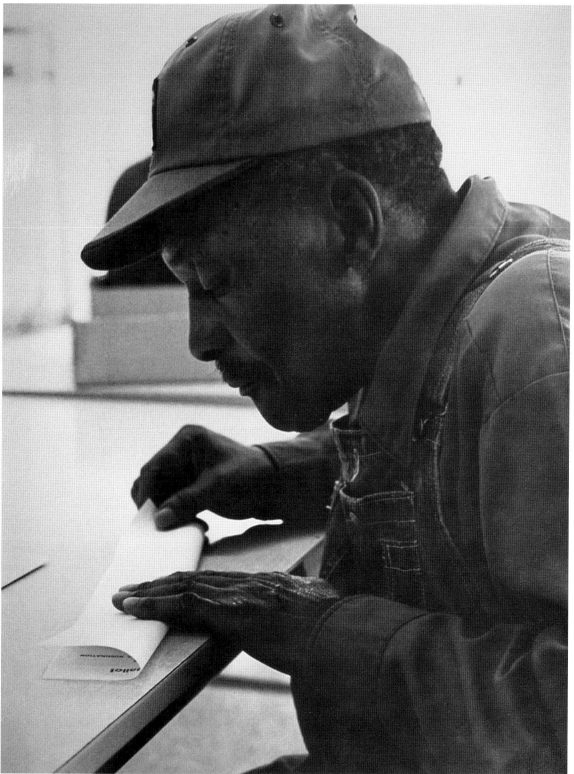

George Craig, 72, carefully marked and folded his ballot on Voting Day in 1978, after a city clerk read aloud his choices in an election in Glasgow, Missouri. Two unidentified women opt for the curtained booths provided for voter privacy.

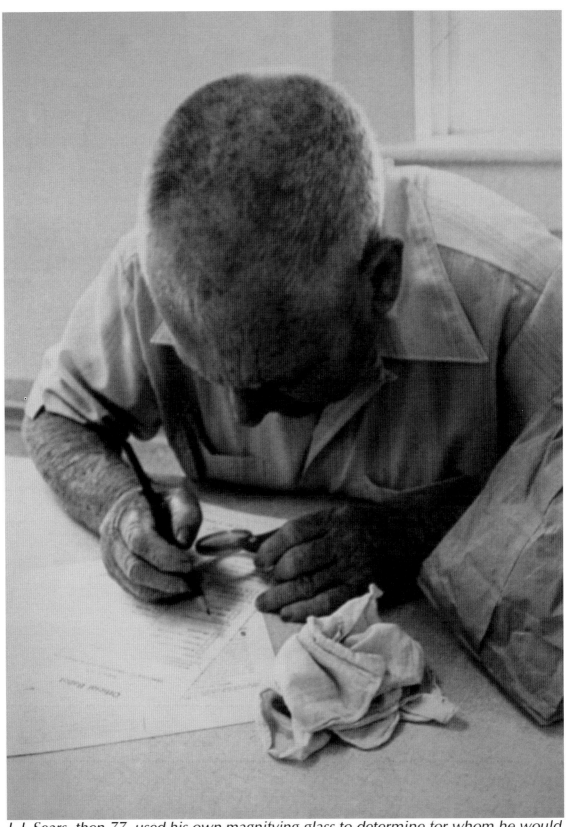

J. L Sears, then 77, used his own magnifying glass to determine for whom he would pencil in his vote on a paper ballot, on election day in Glasgow, Missouri in 1978.

Having the Last Laugh

When the ice melts
And continents are cut in half,
Success will mean surviving a storm
And passion will mean chasing the sun
With someone you trust.
Friendship lasts longer
Than misplaced affection.
Perhaps humans can sustain
Their kind long enough
To comprehend the possibilities in
Getting along.

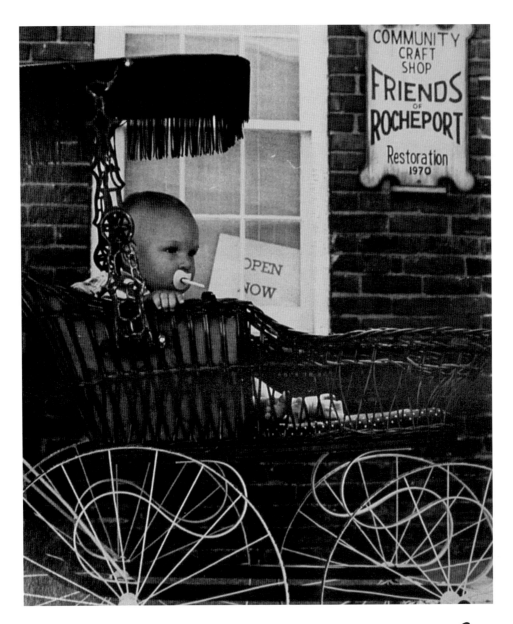

Traveling in First Class Comfort

Certain satisfaction in sipping whiskey or sucking on a pacifier,
Chewing gum, blowing bubbles, slobbery kissing that follows
Humans from infancy through adolescence to assisted living
As in nursing, blowing, whistling, snoring, spitting, smoking.
Born with the need, the mouths, the lips to facilitate, we find
Some of these activities considerably more desirable than others.
We discover the differences between what is healthy and acceptable,
What isn't, and what is defined as strictly a matter of personal taste.

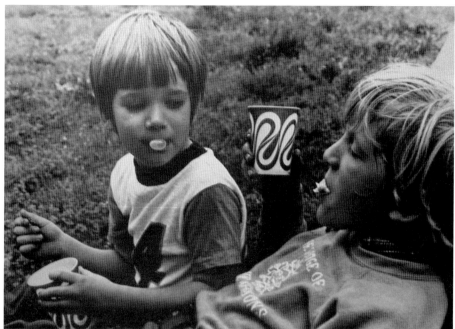

T. W. Blevins & W. M. Hampton, Picnic, Huntsville, AL

Pre-programmed for Parenting

Our step-children, adoptees, fostered, housed or financed
From some remote front, or those we biologically produced,
Compel our devotion, unconditional sponsorship from diaper
Changing to cap and gowning, crib to dorm to apartment,
Stroller to bike to any number of wheeled vehicles,
Teething ring to braces to general maintenance, glasses,
Clothes, shoes, and sports equipment, field trips, birthday
Parties, music lessons, haircuts, vacations, family visits.
All available energy. All available care. All available cash.

Those who appreciate the concept of family understand.
With unconditional love, they comprehend what it means
To be a willing parent. Those who don't should work
In an orphanage, teach school, observe court proceedings,
Manage a prison; work to restore a natural disaster area.
Serve citizens of some starving village in a foreign country.
Or, failing those opportunities, go baby-sit for the neighbors.

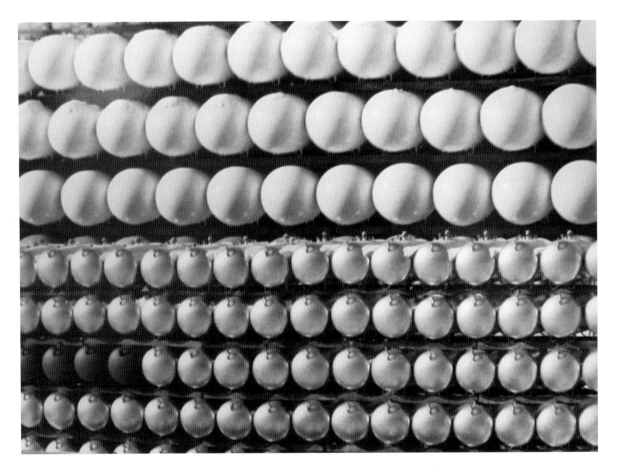

Light & Academic Reflections

At thirty thousand feet, in sunlight, needle point reflections
Outline rows and rows of pleasing shapes of storage tanks.

At ground level, these appear to be a choker necklace
Laid aside by some giant being, ideas to press the viewer
Into rumination on visual metaphors, verbal questions.

Round shapes, reflective surfaces, orderly arrangements,
Stacked, uneven lines, simplified backgrounds, signs.
Something environmental, sensuous, an illusion.

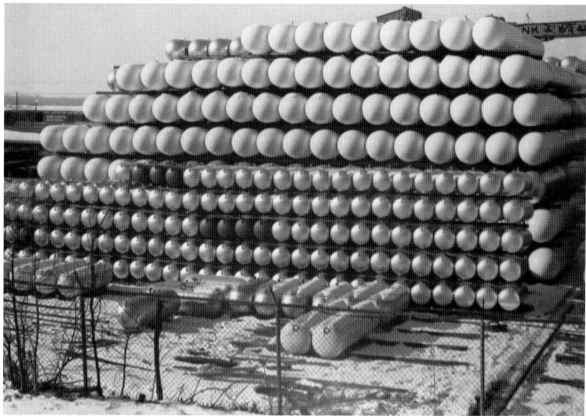

Tank storage facility near the Mississippi River in Missouri

Visual Answers to Verbal Questions

See the snow? The fence? Bridge? Railroad car? Pearls?
Shadows are inviting. Shape and contrast within the frame
Help the imagination better discern what is being seen.

Our minds attribute characteristics or significance to
Objects not ordinarily considered. We are transfixed.

The viewer responds to more than black and white shapes.
A two-dimensional picture of objects in space,
Recorded as a mere fraction of a second in time.

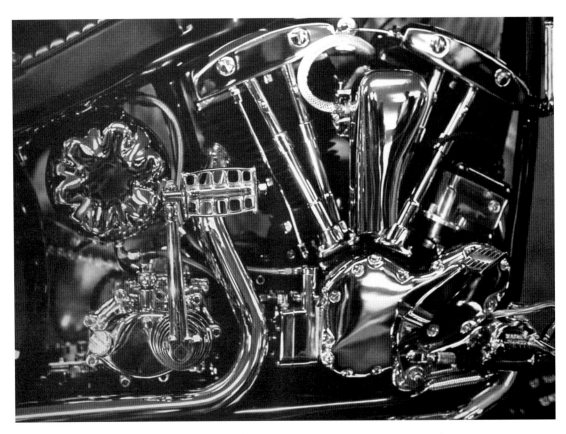

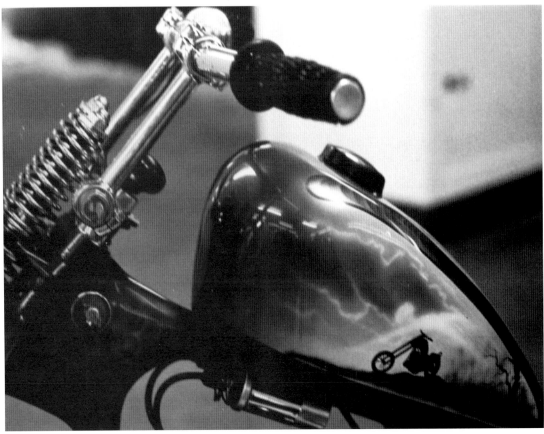

Spirit Transport ~ The Sound of Shine

Two wheels and an engine of chrome-coated steel
Clutch and break with speed to lift a soul and send it
Down highways in the bass rumble of torque and squeal,

When the form-fitted, fine leather saddle eases with the meat
Of the rider and holds firm through a body's lean into tight curves,
When the mirrored gloss of the painted tank is filled with heat,

When the springs are tight, the oil clean and a clear night invites
Riders to blast, to roar along a highway toward their dreams,
Sailing with an electric connection between brain and sight,

When friend or lover, or competitive brother sails behind
And the tires grip, pedals grab -- heavy machine avoids the slip
Through gravel or ice, the deep gut feeling is so nice, so fine.

The engine, the night, the rider, the bike, all one and the same.
The glow, the smoke, the sound, the shine, the race, the game,
The gut-glory sense of self and soul propelled through time

Make the cost, the labor, the risk, the danger, all so tame.
The sound of shine is sweet as wine and partly flame.

Motorcycle engine and fuel tank: Convention & Exhibition, St. Louis, MO
Poem: Tribute to the annual August gathering of cyclists in Sturgis, SD

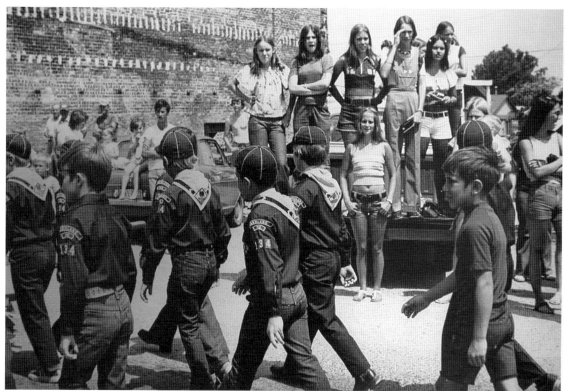

Parade in Boone County, MO

On Parade & Sideline Reviews

Girls watching classmates, friends and brothers,
Cousins, neighbors or potential first lovers,
Happily cultivate their taste for men in uniform,
Studying grins, stride, size, shape that reflect the norm.

Contrary to the popular activity among the Scouts,
Of watching girls stroll arm-in-arm, giggling,
Hair-flipping, hip-wriggling, finger-waving touts
Designed to raise the level of hormonal activity.

Boys in uniform create an impenetrable block of protected identity.
Marching along in step with their soldier-like formation of masculinity,
Certain no parental or Scout leader entity
Sees them glance askance or lift a chin sideways to acknowledge
The allure, the beauty, from those clearly representing femininity.

Venetian Effect

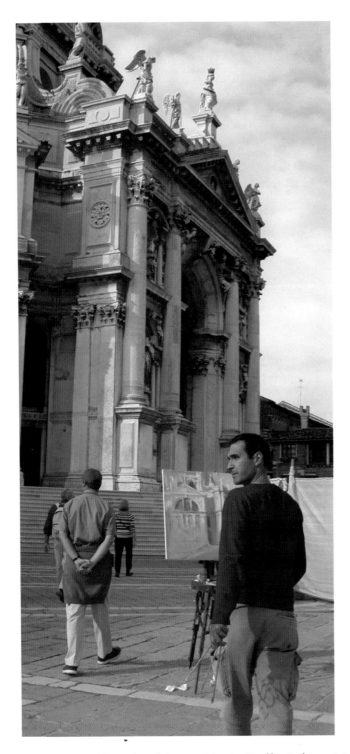

Obsession
Possession
Infatuation
Fascination
Fixation
Placation

Admiration
Contemplation
Consideration
Imagination
Assimilation
Rationalization

Clarification
Justification
Scintillation
Sensitization
Elevation
Elaboration

Oxidation
Ionization
Excitation
Temptation
Frustration
Exasperation

Serendipity,
Propensity, Affinity,
Levity, Clarity,
Charity, Beauty, Infinity.

Church of Santa Maria Della Salute, Venice, Italy, Architect Baldassare Longhena;
Venetian Senate voted to erect the church when a plague abated in 1630.

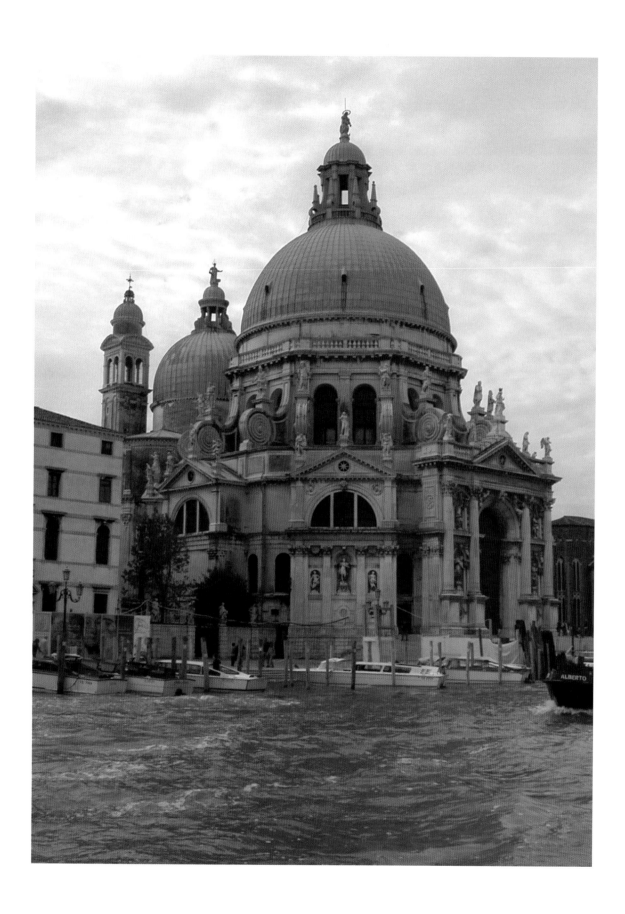

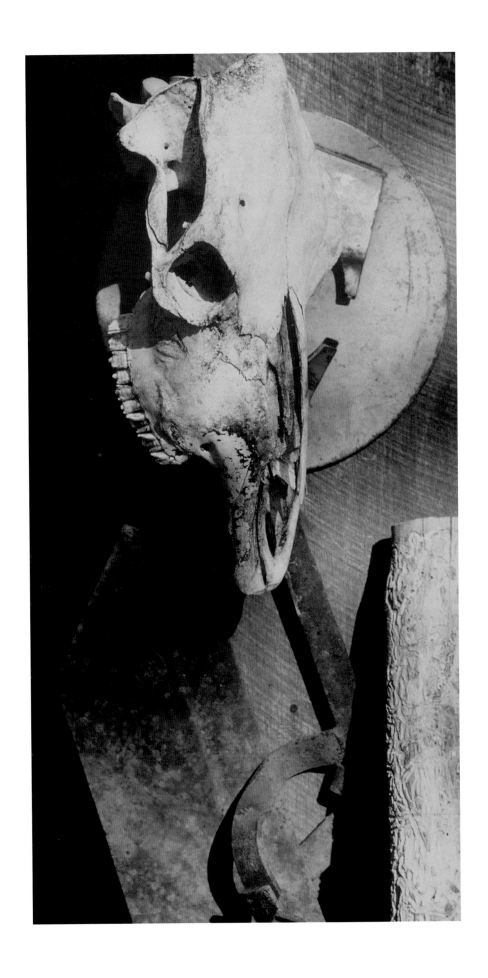

Bone, Tin, Iron, Wood

We retrieved this skeletal tribute off a pile
From the north forty 'while back, and hung it,
With other parts from out th' barn 'bout a mile,
Hung them on the side of the old cedar shed.

Months later, left to weather, rust, dust,
Burrowing insects, summer sunlight,
That skull became new art begging a record
On film, or to be preserved in paint, type, or ink
For others who appreciate form and consequence
 From found objects.

It is the mystique of origin, solidarity of bone-depth
Dimension, seduction of primal shapes, line and color
That provokes the soul of the artist,
Inspires a need to know what's felt about
A mere skeleton, tank lid, plow blade, cedar post.

To record in one image apparent past and present
Showing what was, and may yet be for all living things,
These objects having existed beyond their usefulness,
Becomes the heavy subject matter
 Of your poems and her paintings.

For Poet Jane Schneeloch, Springfield, MA
& her skilled tribute to Artist Georgia O'Keeffe

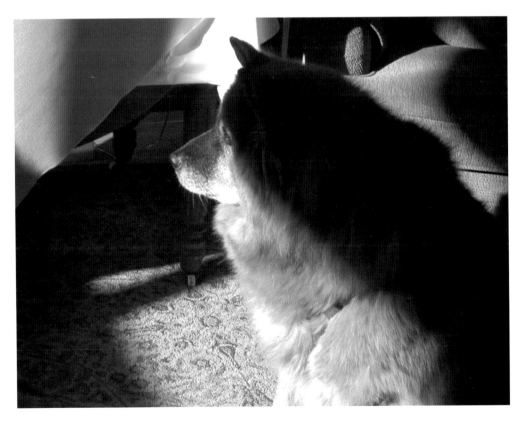

Augustus Bear, Chow/Collie Mix

He wanders unfettered, carries a lion's mane
Efficient hindquarters and capacity for pain
From a merciless jaw at 3,000 lbs. per square inch
To protect those who would threaten the devout
And harmless to those who'd open the door
Or accidentally pinch his ear when he wants out.

He has no edge. Needle-like ivory porcelain
Is his weaponry against intruders, brittle prongs
From each limb protrude and his furry outline
Softly curls into the brocade of his sacred pallet
In deep curls of gold and reddish brown shine.

Eighty pounds of wet wool odor, damp earth, grass
Bushel baskets of hair strewn on every surface
Where vacuum cleaners cough and grind and sass
Their motors smoking from the weave of hairy clog
Rawhide chewies pervade the area, crumbs amass.

He sleeps. Should any creature feline, bovine, equine
Violate his view or sense of smell, announcements will
Wake the dead and terrify visitors from their minds
While anything in uniform that brings the mail
Will trigger loud and vicious declarations of the kind
That should be interpreted as warning signs.

He occupies the space between the bed and bath
With the single detail that justifies his canine wrath
That is, his unconditional love for his human cohabs.

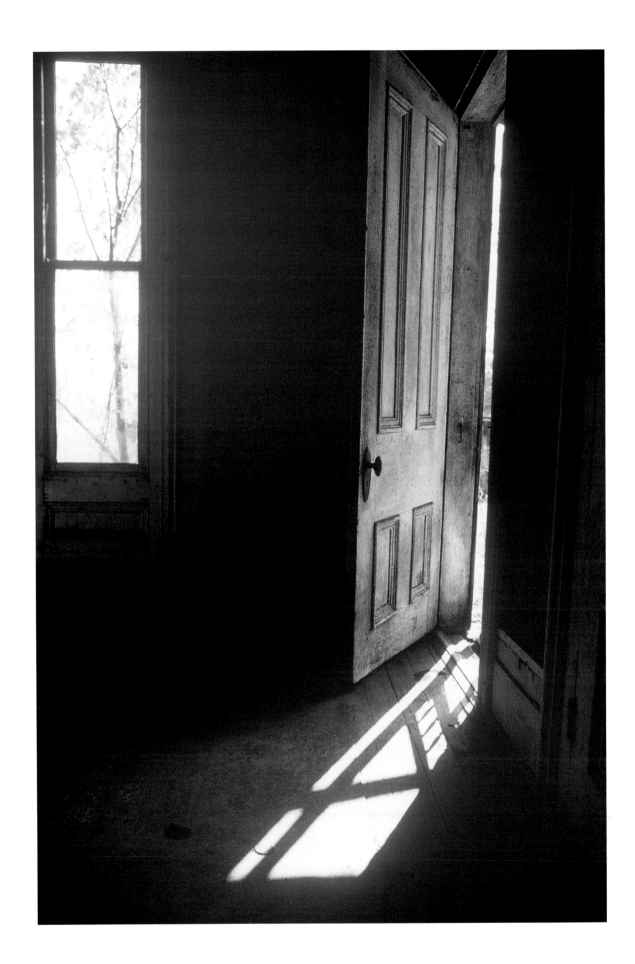

Conversing With Unseen Generations

*"To sit alone in the lamplight with a book spread out before you,
and hold intimate converse with men of unseen generations –
such is pleasure beyond compare." ~ Kenko Yoshida*

We crave connections to the past.
We seek new knowledge that will last.

Our hearts unfold when filled with love.
Our souls resist the push and shove.

When all the thoughts we share from need
Are found in other's books we read
We learn the possibles for human life
And put aside our numbing strife.

Intimate Converse with other's shared
Brings hope that we can dream and dare.

*Photo from the living room of a temporarily abandoned home, Eagleville, TN;
The rambling old homestead, recently restored, is now fully occupied.*

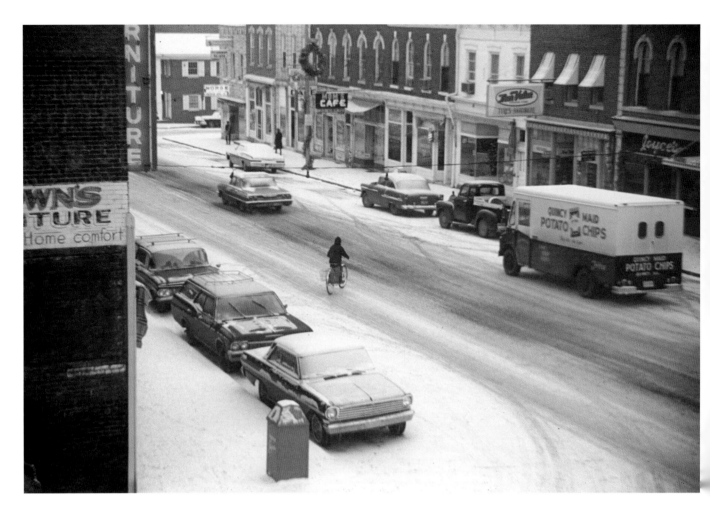

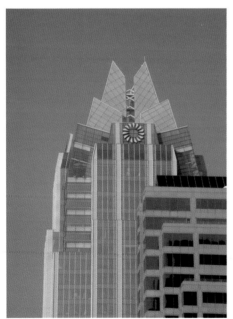

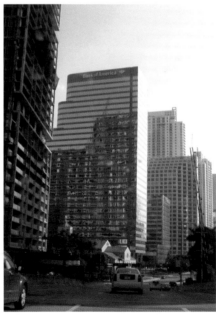

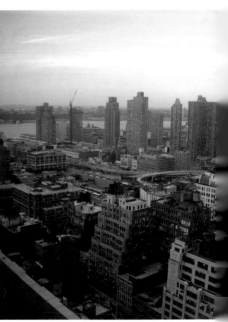

Venturing Into Foreign Territory

Grasshopper on the edge of the fishbowl.
Blessed with perfect means of escape
Slips along the edge of smooth glass.

No way to get a grip
On the rim of potential disaster.
So he sits still, makes no sound.

Water in the bowl is clear and deep.
Jagged rocks like words line the bottom
Where carp, swordfish, couple of mollies
Dart, swish, splash in each other's wake.

Bodies warm the water, lost scales
And carbon dioxide cloud the glass.

Grasshopper in time obliged to find
Leafy sustenance, security elsewhere,
Leaves the slippery edge of the bowl
In one great leap of instinctive faith.

Later, devouring grain, he sees himself
In the eye of the snapper blinking below.

Palmyra, Missouri main street, winter in the 1970's ~ small, rural town west of Hannibal.
Austin, Texas, downtown. View from the sixth floor of the Radisson Hotel in 2007.
Biscayne Blvd., Miami, Florida. Cruising through areas of new development, 2007.
View from the 18th floor of the New Yorker Hotel, Manhattan, 8th Avenue at 36th Street, 2005.
View from the sidewalk, Aon Center, originally the Standard Oil building in Chicago, Illinois,
1979, second largest building in Chicago to the Sears Tower, Designer: Edward D. Stone.

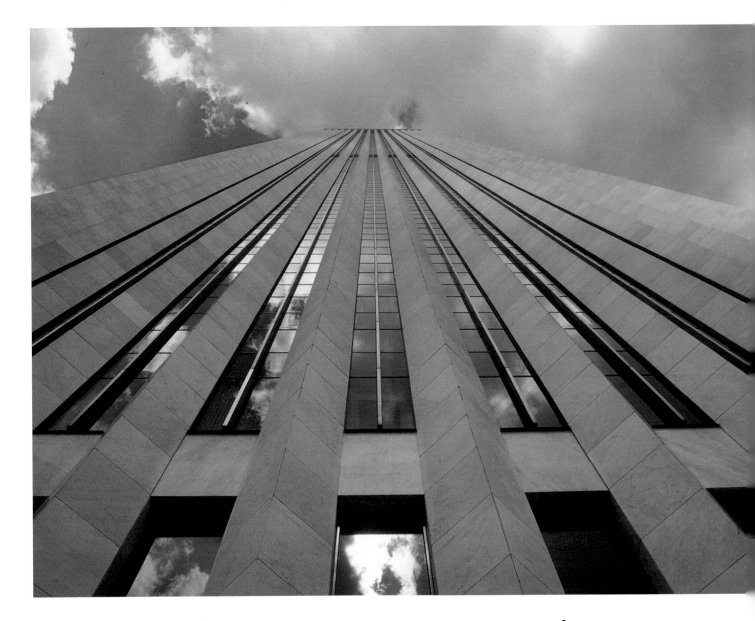

Elementary Lessons in Visual Literacy

Light travels only sometimes in a straight line.
Photography is not a universal language.
Photographs are subjective, judgmental and personal.

Photographs represent reality that amounts to a fraction of a second.
What one sees or feels while looking at pictures, is what one
Brings to the viewing, or, all of his or her life experience.

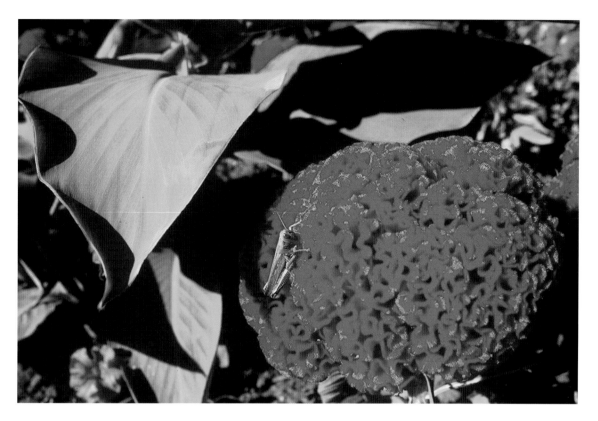

"A grasshopper rests on the crimson, carpet-like surface of cockscomb," states the obvious and merely identifies the subject.

Words With Photographs Matter ~~

The significance of what is visible in a photograph is not always understood by the viewer. Words point out what is not known. Words connect one image or idea to another. We want to believe that photographs represent truth. The above photograph does represent truth about one, small, gardening adventure. However, skillful manipulation of images in contemporary media proves not all that is seen actually exists. The truth may be enhanced or altered for editorial purposes. Editors may add or delete grasshoppers. Words may explain how, why, for, or by whom a picture is altered. Words *interpret* for the viewer. Therefore, words correct our first impressions, explain details, validate facts, comment on the importance of the information, or one's purpose.

Simplify. Simplified!

While teaching, one learns
Much more than can be taught.
In photography, one expects to record
Almost all that can be seen.
In life, one hopes to experience all
That is possible to know and feel.
However, we learn to be selective.
Turns out, *selectivity* is a primary
Lesson in photographic composition.

Three photos: Guntersville Lake Lodge,
Northeastern Alabama State Park

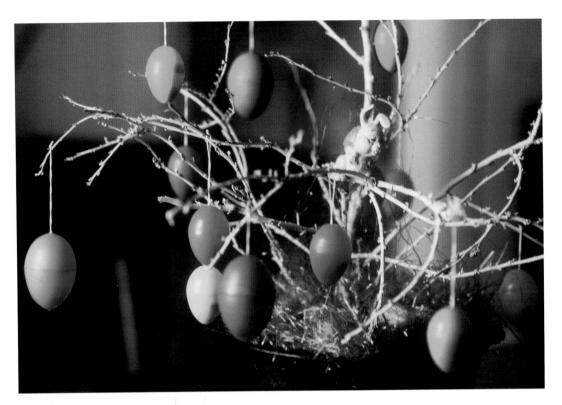

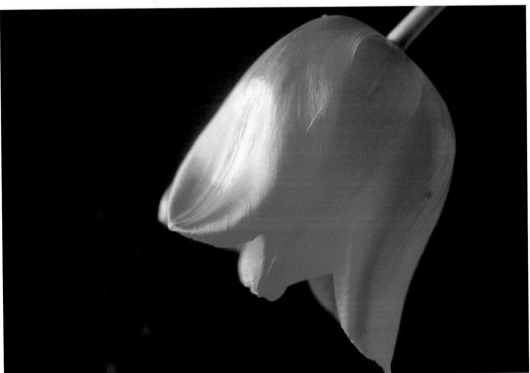

Plastic eggs filled with quarters decorate a child's Easter Tree, complete with a rubber rabbit. A tulip blossom exemplifies RED and the colors of the windsock over the swing on Bluestocking Hollow Road match mood and hue of plastic eggs.

Color for Pleasure & Survival

Human senses are keyed to color we can see so keenly
We think we can hear, taste, smell or feel the prism
Comfort of rainbows. Hear moonlight. Feel oceans. Taste flight.

Royally thick juices of crimson and purple
Leak from a blueberry, raspberry or cherry cobbler,
Indeed, sometimes we think we can taste color.

We want red cars, red balls, red lipstick, red nail polish,
Red windbreakers, red apples, anything packaged in red,
From chocolate, to oatmeal to loaves of white bread.

Meanwhile, we, the restless, silly, lonely, vainglorious humans
Want everything in color, so as to detect invitation, or danger
The distance to what is yet to be conquered, and the pleasure.

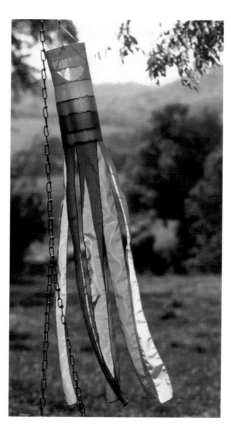

Lure of Color in A Seasonal Seduction

Come into me and photograph my anxious green, said April.
Bring someone who understands yellow, she said. For months,
All roads lead toward the snow-white, rust-wounded dogwoods
Of May. Beyond the dust and heat of harvest in June, July or August,
Come savor the Bronze and Gold of September.

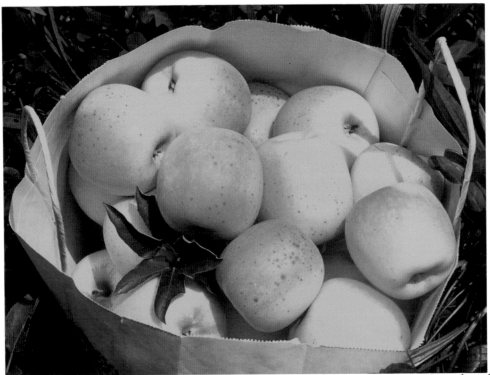

Golden Delicious Apples of September in a Missouri orchard

To April

Once I knew a man who slept in wet, green grass and sunshine.
Even in January he would dream of losing himself to April.
Now I know a woman who sleeps between cool, white sheets
In moonlight and even in January, dreams of changing her name
To April.

Departure & Lift-off On Time

For the moment, time is within the frame.
Distance is inviting. The present? A freeze-frame.
Souls stretch to fill the space with arms hung limp.
Hands are hooks for laptop, book and Burger Blimp.

Share few words or none at all. Move with the crowd.
Warmth is a presence, a nod toward the clouds.
Walkway noise clatters, is barely heard, dimly seen.
Remembered pictures are poetry and color for comforting.

Now becomes the urgency
In light and dark emergency
Pushing through security,
Ticket, visa, pass, immunity.

"Flight 1370 now boarding. Gate C 14."
Strong winds over Nashville so they claim.
A metal tank, metallic boards for wings, engines aflame,
Lifts off. Out of time. Out of the frame.

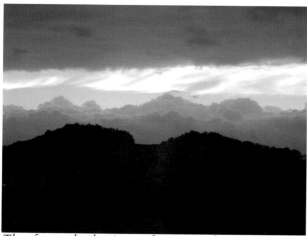
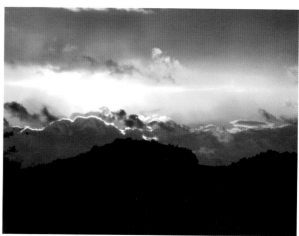

The front deck view of approaching storms~ *B & H Farm, Southwest Bedford County, TN*

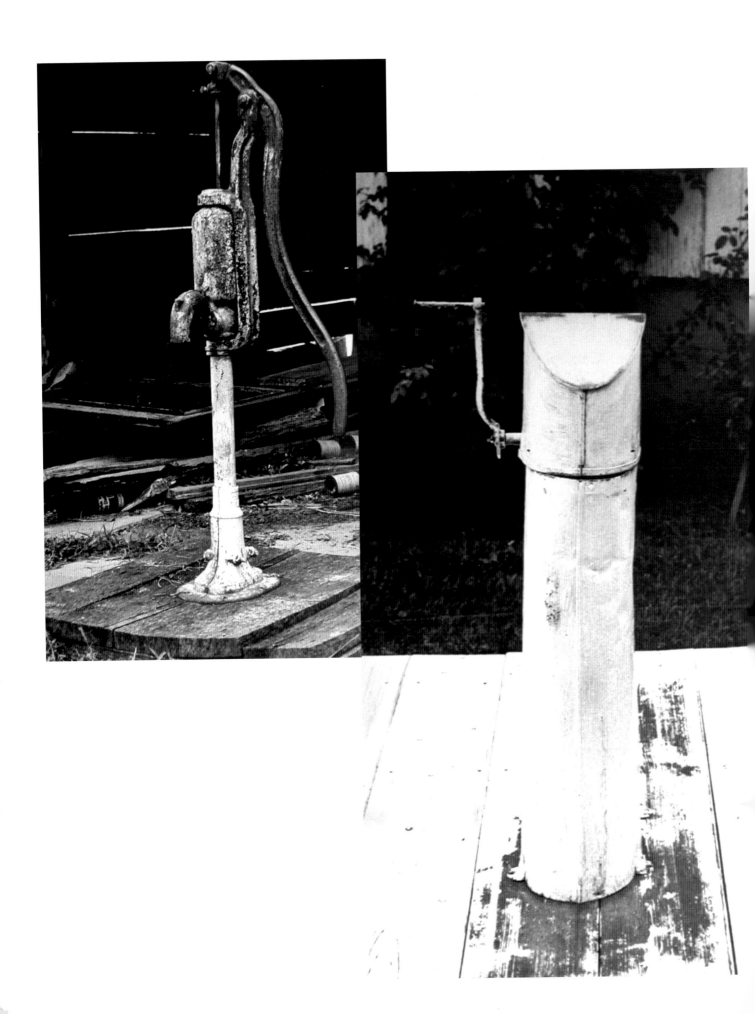

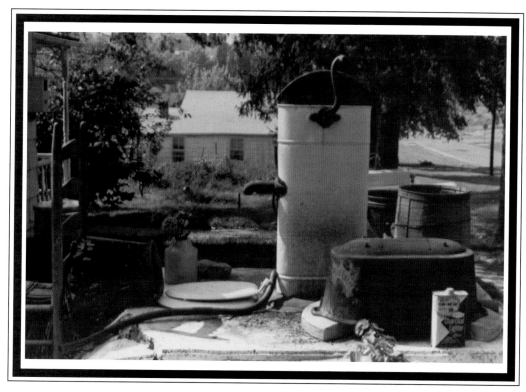

Expanded Terms of Usefulness

Beauty and utility remain in old and broken things.
Pump on the old cistern used now only for watering tomatoes
Salutes as guard to a collection of no longer necessary items.
The cane bottom chair, still sturdy but with its seat come undone.
Coal bucket used to carry ashes, soil or fertilizer to the garden.
Ceramic jug holds a bouquet of dried hydrangea,
A broken toilet seat, saved for who knows what purpose?
The large, cast-iron kettle once used to boil clothes or fry fish,
A wooden barrel for packing and shipping fragile items,
Bent nails, broken screws or trimmed pieces of shingle, some
Plastic bags or paper plates and plastic spoons, a sadder use.
All rest near Mr. Dibble's can of lighter fluid, which could be an
Editorial comment or a sign of intent, the only contemporary note in
This pictorial symphony of once important items that may never have
Been truly loved, but for their term of usefulness, were appreciated.
Each used-up object is a detail in someone's personal history.
All are part of an exhibit on this broken concrete platform,
Arranged like objects in a museum, as if someone still cares.

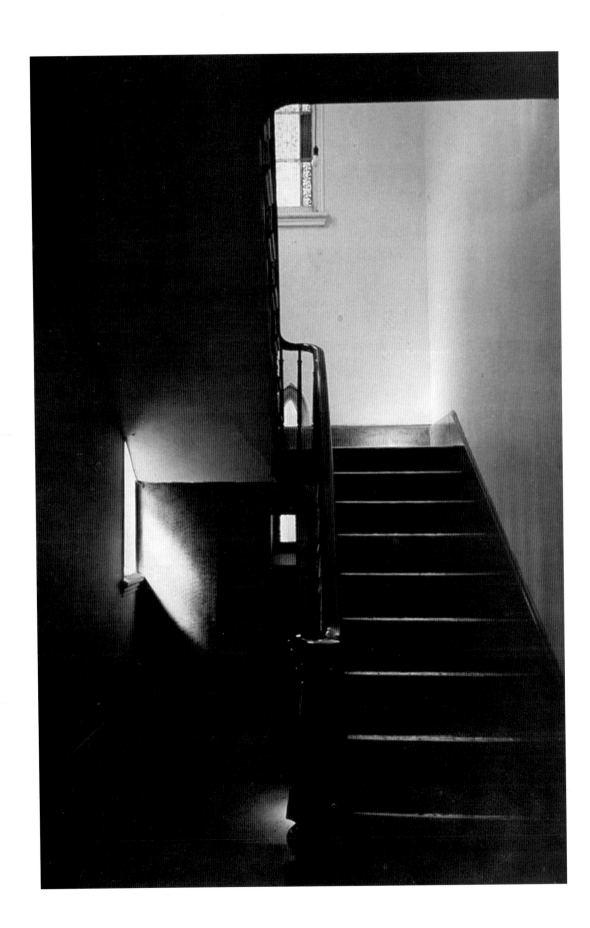